ABANDONED
MEMPHIS

JAY FARRELL

America Through Time is an imprint of Fonthill Media LLC
www.through-time.com
office@through-time.com

Published by Arcadia Publishing by arrangement with Fonthill Media LLC
For all general information, please contact Arcadia Publishing:
Telephone: 843-853-2070
Fax: 843-853-0044
E-mail: sales@arcadiapublishing.com
For customer service and orders:
Toll-Free 1-888-313-2665

www.arcadiapublishing.com

First published 2020

Copyright © Jay Farrell 2020

ISBN 978-1-63499-252-7

All rights reserved. No part of this publication may be reproduced, stored in a retrieval system or transmitted in any form or by any means, electronic, mechanical, photocopying, recording or otherwise, without prior permission in writing from Fonthill Media LLC

Typeset in Trade Gothic 10pt on 15pt
Printed and bound in England

CONTENTS

 About the Author **4**

 Introduction **5**

1 Journey Motel Court **7**

2 American Snuff **17**

3 Vance Middle School **46**

4 W. T. Rawleigh **64**

5 William C. Ellis & Sons **68**

6 Highway 61 Drive-In **86**

7 The Sharecroppers' Cabins **95**

8 The Streets Have Eyes **101**

9 Galleria of Antiques **110**

 More by Jay Farrell **126**

ABOUT THE AUTHOR

Jay Farrell is a Nashville, Tennessee, based photographer who loves photographing abandoned structures. He has a passion for utilizing his camera to share the unique, distressed beauty of abandoned homes and structures that most of the world has forgotten. Sharing his adventures with the public through authorship and blogging inspires him as much as the adventures themselves.

INTRODUCTION

The "life after people" feel to abandoned buildings—complete with rotted and caving floors, forgotten contents of yesteryear, and the overall entropy and distress—are what fuels my inspiration. There's a freedom (and a danger) of hitting the open road and exploring the inner city to seek these abandoned treasures. These structures tell a story. My goal while photographing these structures is to tell those stories and be their voice after they've been forgotten, sometimes for generations.

There is a process to my work. I don't force my way in or vandalize and I don't take or disturb anything. This shows a level of respect and reduces liability. These places are sometimes a hideout for squatters or vandals, which adds potential danger to the situation. It's extremely rare for me to be confronted by an heir or property owner, but it can happen. The structures are dangerous, with roofs caving in, broken glass, nails, needles, wildlife, loose boards, and weak floors. You must know what is under your feet—another reason I prefer to go with a trusted colleague if that option is available. It's eerie; there are lots of noises, creaks, and constant echoes.

This book features the work from my travels and adventures in Memphis, exploring the city streets and once thriving industrial areas. I will take you with me on a journey through some of the most character-filled historic Memphis landmarks of yesteryear. You will enjoy an exciting mix of derelict factories, warehouses, an inner-city Memphis school, and other rare abandoned discoveries.

It's not for the faint of heart, but the walls always tell stories and I enjoy the adventures. In this book, I make my audience part of the adventure. I take you up close and personal to these forgotten structures, far deeper than the roadside view. Through my lens, you will experience the true, authentic feel of the old Bluff City, before gentrification swallows it whole. I hope you enjoy it!

Take only pictures, leave only footprints. [*Illustration by Kelly J. King*]

1

JOURNEY MOTEL COURT

My fellow photographer friend, Mike Payne, a native Memphian, told me about the derelict Journey Motel Court, along Highway 61 on the road to Mississippi from Memphis. Jerry Winnett and I headed to Memphis for a book signing at Novel bookstore and decided to do some exploring while there. I remembered driving this route to enter Mississippi last time I met up with Memphis Mike on the way to my Mississippi excursion.

The area was slightly sketchy, and the first thing I noticed when arriving to the forgotten motel were the two cars parked in front with out-of-state license plates. The complex consisted of a filling station with an upstairs, an office with restaurant and manager's quarters, and a separate one-story wing for the guest rooms. Motor inns were a traveler's oasis, particularly in the days before the interstate systems. In more recent years, non-branded hotels have struggled to keep up with major chains. However, this establishment was probably the oldest in Memphis, being built in 1943, and operated until the mid-1990s. As traveler volume decreased, like many old motels, it became more of a "no tell motel" in later years.

Jerry and I explored the garage and main office quarters inside and out, but we were met with an unexpected surprise when photographing the gutted guest quarter wing. There was a man who exited one of the doors to see what he was hearing outside. His demeanor was calm, but somewhat hesitant and on guard; however, when he learned that we were urban explorers, we shared a good ten minutes of quality conversation. The man was on-site to do some work on the property, and hopefully transform it into retail outlet or art studios. He even gave us a tip on an abandoned snuff factory in Memphis. That told us that he was an urban exploring enthusiast himself, which made the encounter a good one for all of us.

Left: This was the service garage and filling station, with storage or apartment upstairs.

Below: The inside of the garage is bare, so we're moving right along to the second building.

I went around back and observed this angle of the building, and looked for a way in.

This former manager's residence is captured with some lens flare.

Left: Apparently the management or ownership had little faith in the neighborhood.

Below: This character filled building built in 1943 featured an underground storm shelter, as seen in this photo.

Yes, we found our way inside. It was in the process of being gutted.

I'm guessing this was the main lobby area. In this room, Jerry helped a small wren escape through a hole in the window.

I wonder what the story was with this children's bicycle, which must have been there for years. This is what I believe was the restaurant space.

This back view is of the guest room building.

Now you can see the dynamic changed.

Bars over the windows are usually not a good sign for the crime rate of the neighborhood.

Left: Before trying to find a way in one of the guest rooms, I thought I would try the upstairs of the manager's quarters. As you can see, that wasn't a good idea, even for us.

Below: This grim view of the rooms helped me envision some of the business that took place there.

Right: That's nice, but we're just looking.

Below: This was the closest we could get to entering, and right about this time, we had company.

I knew there was a great art scene in Memphis, and we just started looking.

There we have it, the Journey Motel Court! I'm not sure if there were any great rooms upstairs, but I'm guessing not.

2

AMERICAN SNUFF

After the book signing event, and trying some delicious Memphis BBQ, we tracked down the defunct American Snuff factory that our new pal told us about. The American Snuff Company started in 1900 making smokeless tobacco products in New York City. The company moved into this factory in Memphis in 1912, when this building was built. By the mid to late 1950s, the factory was made up of nine buildings in total. At its peak, American Snuff employed 500 factory workers in this facility. In fact, this magnificent old factory was placed on a local historical register.

This original Memphis location of American Snuff Company was in service for 100 years, ceasing operations at this factory building in 2012. The company relocated to a newer, more modern and efficient facility in Memphis, and has expanded to other Tennessee and North Carolina locations as well.

We didn't want to spend much time exploring the front of the building and call attention to ourselves. When we drove past it, it looked like everything was fenced off securely. We went with the more discrete approach and walked the railroad tracks on the backside of the factory. From a distance, we could see the Mississippi River with West Memphis, Arkansas, located on the other side of the river. After a bit of scouting along the tracks, we spotted a hole in the fence that was probably just big enough for us to squeeze through.

At that point, we were on the factory grounds, but there was yet another fence keeping us from getting inside the building. We soon found another access point to crawl through, which commonly happens when exploring abandoned commercial property. For some people, the choice sometimes boils down to staying on the street or having shelter, so they'll make a way in. We appreciate them paving the way for us in cases like this. The property was purchased by local developers who plan on revitalizing the factory for mixed use. I'm glad we got in before the renovation began.

I've always loved the perspective and dimensions of old staircases, particularly industrial staircases.

There was one thing keeping us from this factory: the damned fence. Soon that would be worked around.

At this moment, we had our breakthrough after getting through the second fence. We may have to crawl through the window, but wait—there are open doors over there!

Left: There's nothing more welcoming than an open door waiting for us, particularly doors with this rich of a texture.

Below: Sometimes there is no better view than at first look of a place. First story, wide open.

This shatterproof industrial glass never claimed to be unbreakable, but it's probably a project.

The old factory was made up of so many different rooms, it was hard to know what was a separate building and part of the existing, because over the years buildings were added on. That's good construction.

Some may only see a sliver of sunlight peeking in through a partially open roll-up garage door. I saw an interesting photo.

The spiral staircase going to the second story was quite memorable. You'll see why.

Right: Broken glass makes for uncertain footing, especially on stairs.

Below: Steep and narrow as we went, a total contradiction to muscle memory.

Welcome to the second story.

I took liberty of this vantage point through the window of the steel staircase going up the side of the building. I think that means we entered a different building.

What a fine job they've done staging of materials. Now they're doing it at the new facility.

As we navigated to the front side of the building, this area with a strange pinkish hue had me wondering about the choice of colors.

Apparently this was the other side of the material staging area. It's a bit hard to keep track in a large maze-like building.

Above: Maybe if I hit one of those buttons, a strawberry cake would come down the line.

Right: Only time builds character like this.

Above: By the looks of all the peeling paint, we thought the factory was abandoned for longer than it was.

Right: These steel doors had some heft to them. I tried to operate many of them.

It's a good thing I brought my own water. So much for southern hospitality.

I didn't know at first if this was an old main frame computer or a very large electrical panel.

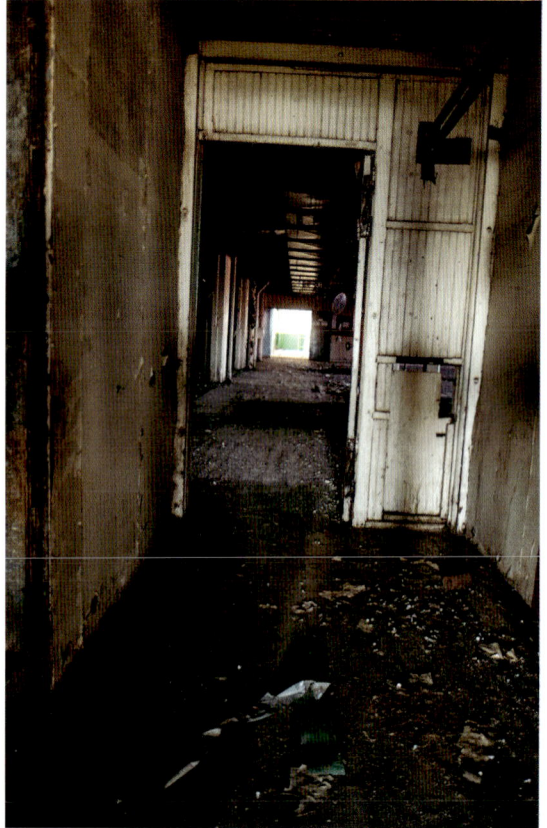

Above: These sliding steel doors on a rope and pulley system still worked.

Left: If memory serves me correctly, this was on the third story, after walking up a dark staircase. Thankfully, I had a small flashlight.

Above: There wasn't much overhead except heavily oxidized light fixtures, pipes, and peeling lead paint. And more than likely, copious amounts of asbestos.

Right: This hallway was a thing of beauty, but where it led was unexpected.

Of course I was wondering where all the restroom facilities were, but it gets better.

Shower stalls that had solid marble slabs—now that I did not expect. I learned from a historian that it was not uncommon for factory workers to shower before going home, so they didn't dirty their cars and get in trouble with the wife for soiling the clean house.

What a magnificent contrast between the old steam radiators and destroyed sinks.

I can still hear factory workers cursing behind that supervisor's back over this not-so-subtle reminder.

I seized the opportunity to capture the light and texture of this corridor to the next building.

That's a positive message I suppose. It's a matter of perspective.

There hasn't been an answer on this line in years, sorry.

That confirms that I was on the third floor.

No matter how many buildings and rooms we explored, nothing felt redundant. It was exciting to see the surprises that awaited us with each area.

Lots of signs and policies, but there's no one around to enforce them now.

This view out the window gave a rooftop perspective of the top of the building, gently kissed by the golden evening sunlight.

If they turn this into an art studio, they already have their start.

Above: Sunlight and pipework make their collective magic, as we are exploring the fourth story.

Right: It's nice to have references like this, to help tell the untold story of this former workplace.

Previous page: The building didn't look as tall from this vantage point.

Parts of this fourth story floor were nerve-racking. There were steel plates covering some sections, so we walked carefully, avoiding certain areas.

It appears that the third and fourth stories get all the bathroom love. This one was a dark pit.

These weren't exactly proper offices, but perhaps where supervisors worked, and product was finished.

I think this is where they ground the tobacco and loaded it into barrels.

This area was filled with character. It was hard to pick a favorite.

Left: I'd wager that the factory worker who operated this plumbing never thought this would be a photo subject.

Right: On the way downstairs to the third level, my final indoor parting gift was this creative but simple artwork.

I will nickname this nook "the courtyard."

How about a nice romantic sunset, at a rather nontraditional setting for such an occasion?

This railroad track view was after our exit of a different building.

This was the street view, which has more curb appeal. Curb appeal wasn't why we were there. I hope you enjoyed this rare and unique find.

3

VANCE MIDDLE SCHOOL

Jerry and I felt the need for another exploratory adventure in Memphis on an early June morning, so the cameras and coolers were packed, and off we went. The weather was having wild mood swings, from thunder and rain to sunny and hazy, followed by more cloud cover. After a tour of Orange Mound, White Haven, and other neighborhoods, we approached the downtown area. Our obligatory Memphis tourist experience was driving past the famous site of the Lorraine Motel, where Martin Luther King Jr. was assassinated, and Beale Street. We soon spotted a fenced-off school, which had an abandoned look, so we circled the block to get a better visual.

Our suspicions were correct. After assessing the vandalism and other signs of blight in the structure, we knew this was a subject of interest. This was exciting, because abandoned schools are a rare discovery. The back entrance was also fenced off; however, with great fortune, there were plenty of openings to enter. Could this mean others came before us, and we would encounter them inside? Thankfully, we found a way inside the school relatively quickly as well. As a gentle rain drizzled on the former athletic field of the school, we surveyed the scene along the way before entering.

Vance Middle School was built in 1971, and taught students in grades 6 through 8, all the way until approximately 2014. According to all records I found, the school closed in 2014, but a calendar in the office ended at 2011, which made me raise the question. The school wasn't in particularly bad structural condition—it was just cosmetically grotesque and depressing, with few windows and dismal colors. The most challenging part of this journey was navigating through very dark wings of the building with only smartphone flashlights, while hearing echoes of debris crunching under our feet.

The building is scheduled for demolition, but sometimes the duties of government are carried out slowly. The Memphis inner-city rugby team uses the old Vance Middle School field, so the school's legacy of helping people lives on.

The rugby team may be the ones to thank for the wide-open arms welcoming us.

Did I not tell you this building was among the most grotesque?

I was hoping the graffiti outside was an indication of what we would find inside.

Welcome to school, sorry if maintenance fell behind.

How is it that football helmets end up in the sewer grate? I suppose we'll never know, except that someone made it happen.

Though this pentagram painted on the wall led the indoor exploration, there wasn't much graffiti to follow. Or they didn't have enough flashlights.

Above: This was the last time we saw ambient light, for a short while at least.

Left: It's okay, I wasn't thirsty anyway, I had my own water.

If any of those wall clocks were right, it would have been very unsettling.

Someone took their frustrations out on this bathroom.

Left: This stairway took us to the second story.

Below: This was one of the few rooms with a view, or windows I should say.

Freedom of expression sometimes comes with the price of meaning nothing.

Modern-day middle school students may not even know what that CRT television was.

Left: A steel door, despite having shatterproof industrial glass, isn't guaranteed to withstand the right amount of force.

Below: I will take that into consideration.

Above: Now we are getting somewhere. The school system hasn't failed this guy's creativity.

Right: Welcome to the science lab. I saw nothing scientific left behind.

That eagle is saying, "I see you, and am watching you." That's not one bit creepy, especially in the dark.

I got inside this place, didn't I?

56

The main school office had little left behind except strewn rubbish.

I'd say this is the control panel for the fire alarm and/or sprinkler system.

This bare library probably had a fair selection of both fiction and non-fiction as advertised on the walls.

I wasn't supposed to be in the librarian's desk, but no one was around to say anything about it.

The old projector pictured here sat in a dark closet next to the auditorium.

All we had were our smartphone flashlights to help us navigate in the dark, and even provide light for the photographs. I ended up using a tall lightbulb box as a makeshift camera tripod so I could drag the shutter and expose this dark scene as well as possible.

I've seen crime scenes not look as ravaged as this trophy case.

Apparently the school ran a concession stand for auditorium performances and athletic events. You're in for a special treat.

Since all ingredients are slightly past prime, nachos are half price.

I photographed this dark gymnasium using a small table for a tripod, and two phone flashlights. There was a slight buckle in the hardwood floor, one of the few signs of natural distress.

A lone antique metal stool sat in the dark hallway with only a sliver of light forcing its way in.

My first thought was, "Why would anyone need to know the chemical elements for epiglottis?" A dedicated educator at Vance Middle School made sure the young grasshoppers learned that important lesson.

This photo has distress, color, texture, and lines. Possibly a contender for an art exhibit.

4

W. T. RAWLEIGH

While on the road towards downtown Memphis and doing some random exploring, I spotted these two badly deteriorated, derelict factory buildings and knew we needed to investigate. There was a distinctive weathering and seasoning to the 100-plus-year-old brick and concrete structure. The exterior steel staircases were rusted, but still secured to the building. Many windows on the upper levels were shattered, and all ground level entrances were heavily secured. It appears as though some demolition or other construction had begun on the property, and there were "no trespassing" signs everywhere. We still wanted to get inside to explore, but it was not feasible.

The first instinct, despite enjoying the majestic ramshackle exterior, was to be somewhat disappointed about not accessing the inside. We noticed water falling from the roof, and then discovered a water tower on the rooftop. By looking at the discoloration of the bricks from the collecting water on the roof, we realized that the roof and floors would be in horrible shape. Maybe it was for the best, though we still wanted to know firsthand. With active construction beginning, either way, history has been captured, because the building's future changed drastically soon after photographing the buildings in this blighted state.

In 1912, the W. T. Rawleigh Company expanded its operations by opening this Memphis factory and distribution center location. Rawleigh was a pioneer in direct customer sales and mail order sales, bypassing any retail stores. The company manufactured and sold all kinds of household goods, personal care products, and myriads of other products. The company thrived because of its reputation and convenience, using only door-to-door salesmen and mail order to peddle its wares.

Manufacturing ceased at this Memphis factory in the late 1950s. The buildings were then converted to company storage and distribution warehouses, until the late 1970s when Rawleigh shut down operations in Memphis. Other companies occupied the buildings for shorter stints, before sitting vacant. W. T. Rawleigh Company continues to operate today, still independent from stores and retailers.

Above: I suppose it's a change to see graffiti that doesn't include phallic symbols or Satan.

Right: We're looking at over 100 years of history here.

In the event of fire, jumping off a 12-foot roof seems like the lesser of two evils.

Perhaps the lower staircase level was lopped off to deter entry or vandals. Nothing stopped these guys with paint cans.

This angle is my favorite—urban decay at its finest.

I caught this old school treasure in the nick of time. This rubble demonstrates work has begun.

5

WILLIAM C. ELLIS & SONS

Part of the Memphis experience, or when traveling anywhere away from home, is getting a taste of local flavors and local experiences. Jerry and I had a delicious late lunch at Central BBQ in downtown Memphis, and then did some more exploring on foot. We approached the abandoned city-block-long William C. Ellis & Sons Machine Shop, having no idea at the time what a legendary Memphis business this was. At the time, we were smitten with the character of the historic building, and were in disbelief that it was wide open for us. However, we weren't about to look a gift horse in the mouth.

William C. Ellis & Sons started as a blacksmith shop *circa* 1879. The shop made horseshoes, carriage parts, steamboat parts, manhole covers, cannonballs, and more. In the early 1920s, the company expanded and built a machine shop and pattern shop. As demand grew for different manufacturing and metal casting, the company produced railroad car and locomotive parts, river boat parts, gears, cotton compressing equipment, and other agricultural equipment.

It was quite an experience walking through this giant machine shop filled with history of manufacturing technology, and how it has evolved throughout the nearly one-and-a-half centuries the shop operated. Skilled workers lined up donning blue work clothing with sweat pouring from their brows while operating steam hammers, presses, chain hoists, designing molds, forging steel and iron, and so much more.

The Ellis Company closed shop in 2016. The company leader, Henry C. Ellis III, decided to call it quits, at ninety-four years of age, while still working at the shop five days a week. That dedication is above and beyond. Developers purchased the property, and most of the equipment was removed or sold at the time of the sale. The buildings were mostly an empty shell. However, the remnants left behind were enough to bring this story to life. The multiple building shop faced Front St., with Linden Avenue (now Martin Luther King Jr. Boulevard) and Wagner Place as side streets. In 1983, the buildings were listed on the historical register.

This was my first view when entering through the open storefront door facing Front St.

After consulting knowledgeable sources, we believe this is a gearbox, driven by external motor, and used as a chain hoist or winch. It likely takes hydraulic fluid or gear oil, hence the check plug seen on the housing.

If you're wondering what nearly 100 years of work and character looks like, this is a portrait of it.

This was a cable and pulley system/hoist on rolling tracks.

Right: The steel cable seen here is as big around as the average person's pinky and rated to lift or pull thousands of pounds.

Below: I tried to notify a supervisor that this beam was off-center, but it fell on deaf ears.

Left: These spare chains for machinery now hang, waiting to rust.

Below: The electrical panels were labeled boring mill, welding shop, blacksmith shop, foundry, and warehouse. Paying attention to the little details that act as valuable clues helps me do better research after my visit.

I thought this looked like an old air compressor (the manufacturer is Reliance), but there was no tank. I asked a friend who works for a machine shop and he thought it was as well. It was likely plumbed to machinery instead of air tools.

The sun is keeping the lonely, once thriving shop company.

Above: "No one is to ride this elevator. No exceptions. For freight only. - H.C.E. III."
The next sign, partially illegible due to wear, contained instructions on adjusting cable when reaching the second floor to shift belt. I'm just nodding as if I understand Henry's instructions.

Left: The support pillar provides many electrical outlets for various machines and tools.

As the sun shone on the loft, it created a warm glow and every dust particle floating through the air was brought to light.

I've always loved visible paths of light, as seen here.

Above: This sign has guided many customers and visitors through its doors for generations. The sign faces Front Street. At this point, I didn't want to call attention to myself until I was finished inside and have been to the other buildings.

Left: Dare we explore the upstairs? Of course!

Above: As I suspected, part of the upstairs level was office space. The top several steps and upstairs floors weren't in the best condition.

Right: It appears this old telephone isn't made to dial out. Only receive calls.

Above: Welcome to the ladies' bathroom.

Right: This very old fuse system was likely upgraded decades before the shop closed.

The offices were enclosed to provide reasonable shelter from noise and dirt/dust.

This was likely a manufacturing jig.

This structure was one of the originals, and was used as the pattern shop. In short, its purpose is to manufacture full-sized molds of parts or products that are being cast.

Across muddy grounds sat the original blacksmith shop, with plumbing from the fire sprinkler system in front of the building.

The basement level of the pattern shop was littered with mud from grounds construction and possible flooding.

Above: The side view of the pattern shop told a different story, one of blight and shattered windows.

Left: Right here, you could once hear banter between pattern shop workers while they load and clear out their lockers. Now it is unvisited, except from the occasional vagrant perhaps.

My machine shop friends didn't know what this was for sure, but perhaps it was a cooling or washing station for parts. This machine shop was from a much older generation.

The back side of the machine shop building had a chunk taken out, which is encouraging that the buildings are carefully being repurposed. Memphis historians urged the developers to do so, which is great for the character and history of the city of Memphis.

As I walked through the wet, muddy ground to investigate these pallets of bricks and barrels, I felt a very slippery oil-like substance under my feet. Thankfully, I kept my footing, as I didn't have a change of clothes with me. Perhaps this was a teachable moment to start doing so.

Filling in this pit was likely a thoughtful safety measure.

This wide view of the machine shop storefront may be one of the last in its original state.

6

HIGHWAY 61 DRIVE-IN

I recall passing by this old drive-in movie theater when on my way to Mississippi earlier in the year, but chose not to stop because it was raining heavily. Once again, after exploring the Journey Motel Court, I passed it again, almost forgetting what route it was on. Once again, I was unable to stop, due to a book signing in town and time constraints. After that, I remembered where it was, and I knew I'd be back in Memphis again. The third time's a charm. Jerry and I parked across the street at a strip mall, and walked down the steep bank through tall weeds and over a partially fallen fence.

This drive-in movie theater opened up in 1956 as Highway 61 Drive-In, with a single screen, closing in 1965. The theater sat vacant until 1968, re-opening as Southwest Twin Drive-In with two screens. During this time, drive-in theaters were in their heyday until movie theaters featured more amenities, the inception of home entertainment and movie rentals, and seasonal operating schedules made the concept less sustainable. This drive-in closed in the early 2000s to the best of my research. In later years, the expensive conversion to digital projection made it impossible for many drive-ins to continue. This particular theater closed before then, however.

Picture lines of people in classic American-made cars and trucks, watching their favorite films while enjoying a cold Coca-Cola or grape slush, a hamburger, and maybe some popcorn from the concession stands. Drive-ins are a memorable remnant of classic Americana. Now this defunct entertainment complex sits on a vast expanse of overgrown land choked with weeds and kudzu. The only other remaining features are cracked pavement, badly weathered screens, and crumbling buildings. The property has been used since for flea market space, just not lately.

All I could ascertain was this building was a restaurant, likely separate from the drive-in.

I've enjoyed some similar dives with handwritten signs with great food. I'm not sure if this was one of them.

This was the office, concession stand, rest rooms, and upstairs projector booth. Notice the sign has the FM radio frequency to hear the audio from the movie, or moviegoers could use the speakers that clipped to their car windows.

The attendant has been unavailable for quite some time.

This was the concession area, likely for popcorn and soft drinks.

That office was a mistake as well. It smelled like urine.

It's hard to believe this is where people were hired and fired.

This was the fryer and grill area, with a range hood overhead.

The time clock was gone, but the timecard rack remained, where workers clocked in and out for their shifts.

The business may be closed, but it's still quite a party spot.

This was screen 1. Or was it screen 2?

I'm not used to seeing large sinkholes, but this was one for sure. Perhaps it was caused by flooding.

The other side of the building showed a different FM radio frequency to tune in.

I wanted to go up these stairs badly, to get to the projector booth. The stairway was steel with concrete poured in the steel molds on each step. One of the lower steps broke apart where the steel rusted through. Jerry said, "I see you're thinking about it. Walk away."

7

THE SHARECROPPERS' CABINS

On the last leg of our exploring journey that day, we stopped in Cordova, a Memphis suburb on the way home to meet one of my readers, Jeff. It was fun to briefly catch up and see his fascination with forgotten buildings and the exploration of them. Jeff said he wanted to show us a couple of abandoned houses near him, so of course Jerry and I were up for the adventure. He lived in a rather upscale neighborhood, so the idea of anything abandoned near there seemed random and unexpected.

The residential streets quickly transformed into two-lane blacktop backroads. Off to the side, there was a concealed, overgrown path that was once carved out between many acres of woods and field. On one side of the path, there was a small cabin-style house, and another one on the other side, both surrounded by trees and a vast expanse of field. Jeff thought these may be sharecroppers' cabins, but we were unsure they were old enough.

The two cabins were nearly identical and likely built in the fairly early 1900s. Each was approximately 600 square feet, about the size of an average one-bedroom apartment. Both cabins had electrical panels, but no evidence of indoor plumbing—only a water spigot outdoors and an outhouse behind one of them. Sharecropping continued well into the 1940s, and even beyond that in certain regions of the country. With the increased use of mechanical and power farm equipment, sharecropping faded out.

This was a remarkable and unlikely treasure, and quite a contrast to the other Memphis locations I've explored, which is all the more reason I'm excited to include this property, reminiscent of a bygone era. The land adjacent to the abandoned cabins was still maintained. The more I researched the subject, the more I agreed with Jeff. That was plantation land and those were sharecroppers' cabins.

Many people talk about minimalist living, but I'd wager they'd want running water. These people lived it, often with large families.

Nowhere in this kitchen or on these countertops do you see a sink, and there were no pipes anywhere. I will say that entering the house was questionable because of the deteriorating floor. But, nothing ventured, nothing gained.

Once filled with humility and love, now the house sits with peeling lead paint and remaining debris scattered across the floor.

This very old Republic Boxwood wood stove was likely the only means of heating. Do you want air conditioning? Open the doors, and windows, if they opened.

There was some great color and texture in this room. The piece in the back looked like a pop-up blackboard to teach children their school lessons.

House number two had a similar stove, made by Winter Knight.

The outside view of the second house was slightly less obstructed by overgrowth. Incidentally, neither house was accessible through the front. But the back doors were partially open. I appreciated that.

Right: The retro green beadboard lining the back porch ceiling is slowly fading into the abyss.

If you can see the bottom of the house, there is no slab or foundation. They both sat on stilts/wooden timbers, partially to help combat flooding.

This piano now sits with weather damage and broken hammers. Jerry told me he met an elderly man whose family were sharecroppers. When he and his siblings were growing up in a tiny sharecropper's house, the piano was the only form of entertainment and luxury they had. That served as a valuable clue.

The birds and other wildlife have now taken residency. These cabins will never be without purpose as long as they stand.

8

THE STREETS HAVE EYES

In weeks following my last Memphis exploration, I made an impromptu trip to go exploring with my new friend, Jeff. Our plan was to explore downtown Memphis and any other places we came across along the way. I spotted an unusual looking abandoned church/mission building in the Berclair neighborhood. I saw no activity around the building, so we investigated. We scouted the outside of the building just long enough to find our way in. Lo and behold, there was a door off its hinges facing the corner street that we were able to squeeze through.

The inside has had a rough journey, with clothes and litter strewn everywhere, a sanctuary filled with street litter and bowed ceiling fan blades, and evidence of makeshift beds that homeless use. Just as we were walking down the hallway to access stairs to quickly explore the upper level, a door at the end of the hallway opened. The man was unsure what to make of us, but was relatively friendly. Another man walked in, with a similar demeanor. He explained to me that the owner of the building allows some homeless to stay there and to be mindful of that. Once we told him what I was doing, he seemed to loosen up. His name was Scooter. I asked him eagerly, "Is there anything upstairs I can quickly explore?" He said yes, and he exited. I briefly explored the upstairs and then went out the way we came, just in case others were waiting for us at the door they entered.

Immediately as we exited, there was a group of three people nearby, two men and a woman. The woman yelled, "What the f*** were you doing in there?" I told her I was just taking photos, as I always do with abandoned structures. She wasn't believing it. I kept my distance but stood firm, and told her, I have no reason to lie to you. I just spoke with Scooter, ask him. She said he was her cousin. The other two men helped calm her down and I wished them a good day, all was right in the world. Off to the next destination.

There are two lessons here. This is the stereotypical scenario that the general public thinks happens frequently to explorers. It's rare I encounter people, and this was the first time I've been met with hostility. It's their turf, and they don't know my

intentions. Most people are receptive if you acknowledge that and are respectful with them, even in brevity. In abandoned buildings, there are usually traces of occupants or vandals, and sooner or later it's possible to meet one. Jeff had quite a test going in, but handled himself perfectly. There are risks to this craft, but using discretion diffused a potentially dangerous situation.

This is the side of the building I looked at first for an entry door.

The only angle I captured of the outside was this one. I planned on photographing the front after exiting, but I think you know why I didn't, assuming you read the story.

A dark grungy stairwell led me to the furnace room.

After entering, this broken piano keyboard was the first thing I spotted.

This sad, beaten sanctuary had some interesting seats, very reminiscent of old movie theater seating.

There isn't much preaching at this pulpit these days.

A walk down the hall to the small office room led me to these dated chairs and painting.

Above: By now, I figured out what Scooter was about to tell me. At this point I was unaware of the encounter.

Right: Didn't your mom ever tell you to pick up your clothes and hang them up?

Above: That door at the end of this eerie hallway is where I was about to have company.

Right: This door was open on the back side of the building where I never went because my first priority was looking for the easiest way in.

So, that's where the church pews went.

Was this storage for an extra pulpit or were there multiple sanctuaries? It was a large building, anything is possible. Then came Scooter and his friend, and the journey upstairs.

Most of the rooms were starting to look similar. The upstairs was not as eventful.

This bed and room with a window sure beats the streets. It was time for us to move on. I hope Scooter and his friends are all doing well. They made this a unique adventure!

9

GALLERIA OF ANTIQUES

My time in Memphis on different occasions has been inspirational and educational, as I was able to learn history and the changes that Memphis has faced over the years. Gentrification has definitely reduced the number of vacant factory, industrial, and office buildings in recent years. Jeff and I walked several miles exploring downtown and the river bluff area. Of course I hoped to access the historic Sterick building, and perhaps even the 100 North Main tower. I had my doubts that would happen, because buildings that tall can't be left open, especially in a populated downtown area.

There were several derelict buildings in the area, but most of the more interesting ones were secured from visitors, even us. Patience pays off, however. A three-story brick warehouse/factory building with roll-up steel doors caught my attention. There was an older lady who was sweeping the front-loading dock area outside, under a roof. She was finishing up after we circled the next block. I asked her if she knew any history of the building. She said it was an antique warehouse, and it had been abandoned for years. She lived in the condominiums behind the charming, endangered warehouse building and wanted to tidy up after several homeless who have no access to trash bins. My first thought was bless her for that, but I still wanted to wait until she left, because I discovered a way inside.

This building was most recently an antique dealer, and was built in 1920. My excitement was off the charts getting inside and exploring. This building represents industrial Memphis of yesteryear, and the urban architectural charm of the past. My whole goal with this book is to include you, the reader, on every adventure as if you were physically with me, as well as to give an inside perspective of Memphis's forgotten past that urban gentrification is swallowing whole. Thank you, Memphis, for being a gracious host (for the most part).

This side view of the warehouse was as the Mississippi River saw it.

This was the loading dock area that the good neighborhood steward was tidying up.

I took this to mean that I was allowed, but my camera wasn't. I didn't let the door see my camera, so I suppose we were compliant. At this point I was waiting for the coast to be clear to enter.

Flaking paint, oxidized steel bars, and warping boards all make up the character in this frame.

There were a few piles of debris to climb to enter, but it was worth it.

This large scale can weigh up to 2.5 tons. The Fairbanks Morse company also made marine products.

This staircase was very questionable, so I waited to investigate the other one.

Every feature had so much character from the doors and knobs, steam radiators, and textures of the floors and walls.

Nothing beats the texture of plaster walls and peeling texture of lead paint.

Someone got very angry when the water fountain malfunctioned, but was that really a good reason to break a window?

There was a lot of roofing and upstairs flooring materials falling to the first floor, as the roof leaked in many places.

I would say they got rid of most actual antiques and left what they didn't care about.

The contrast between the aged brick, oxidized steam radiator, and broken goods in the foreground makes an interesting frame.

Yes, of course I tried it. I'm afraid it was inoperable.

The office space is the only one that ever had air conditioning, but certainly not in 1920.

A crash-damaged Cessna airplane tail may have been the most random item I've encountered in a vacant building. My friend pulled up an aviation report. The plane was crashed in Millington, TN, in 1989. Soon after takeoff, an emergency landing attempt was made, due to lost engine power caused by a clogged fuel flow manifold. One occupant had minor injuries. The other occupant was uninjured.

The wide view of the first floor gives you an idea of its contents and room layout.

Most of the contents screamed "low-budget flea market" more so than antiques, but no one would leave valuable antiques in a vacant building in declining condition. That scale was definitely an antique, however.

This close-up of the buckling wood floor gives you an idea of the state of decay the building is in. Hopefully a rescuer comes along, and not a demolition crew.

I loved the beadboard and fancy millwork on this picturesque staircase.

Above: Sided utility carts prevented valuables from falling off.

Right: This staircase looked a bit more promising.

There was nothing upstairs, and the floors were not the greatest in spots. If it weren't for the freight elevator, I wouldn't have ventured across even part of it. Follow the joists.

This was the only view I could get down the freight elevator. Treat it well.

A rotating fan was the air conditioning, which may not help much in the steamy Memphis heat.

Photography is largely about light, shadows, lines, and texture.

MORE BY JAY FARRELL

ABANDONED EAST TENNESSEE
ISBN: 978-1-63499-209-1

ABANDONED MISSISSIPPI
ISBN: 978-1-63499-179-7

ABANDONED KENTUCKY
ISBN: 978-1-63499-056-1

ABANDONED KENTUCKY
VOLUME 2
978-1-63499-169-8

ABANDONED NASHVILLE
ISBN: 978-1-63499-113-1

ABANDONED ALABAMA

ISBN: 978-1-63499-114-8

ABANDONED TENNESSEE
VOLUME 1

ISBN: 978-1-63499-055-4

ABANDONED TENNESSEE
VOLUME 2

ISBN: 978-1-63499-102-5